D1172568

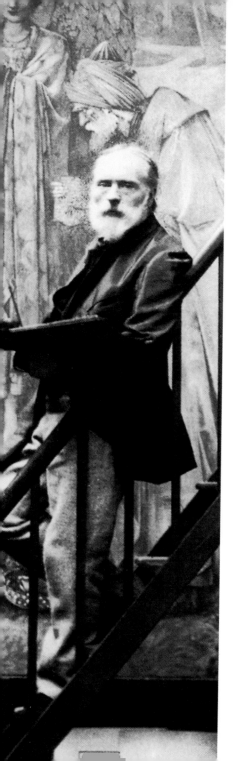

Text: Patrick Bade
Layout: Stéphanie Angoh

ISBN 1–85995–864–8

Printed in France

1. *Burne-Jones working on 'The Star
 of Bethlehem'*, July 27, 1890. Black-and-
 white photograph by Barbara Leighton.
 Courtesy of the National Portrait Gallery,
 London.

Edward **Burne-Jones**

Patrick Bade

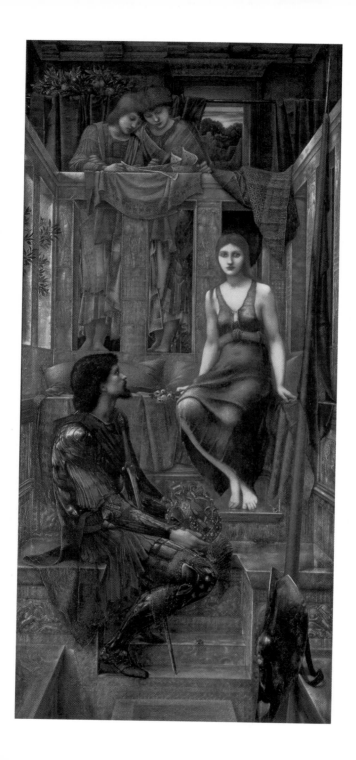

When Burne-Jones' mural sized canvas of *King Cophetua and the Beggar-maid* was exhibited in the shadow of the newly constructed Eiffel Tower at the Paris Exposition Universelle in 1889, it caused a sensation scarcely less extraordinary than the tower itself. Burne-Jones was awarded not only a gold medal at the exhibition but also the cross of the Légion d'Honneur. He became one of those rare "Anglo-Saxons" who from Constable in the early nineteenth century to Jerry Lewis in the late twentieth century have been taken into the hearts of the French intelligentsia. For a few years while the Burne-Jones craze lasted, fashionable French women dressed and comported themselves "à la Burne-Jones" and cultivated pale complexions, bruised eyes and an air of unhealthy exhaustion. The two great French Symbolist painters Gustave Moreau and Pierre Puvis de Chavannes immediately recognised Burne-Jones as an artistic fellow traveller. In 1892, the cheer leader of the "Decadence," "Sâr" Joséphin Péladan, announced that Burne-Jones would be exhibiting at his newly launched Symbolist "Salon de la Rose-Croix" alongside Puvis de Chavannes and other leading French Symbolist and English Pre-Raphaelites.

Burne-Jones wrote to his fellow artist George Frederick Watts "I don't know about the Salon of the Rose-Cross — a funny high-fallutin' sort of pamphlet has reached me — a letter asking me to exhibit there, but I feel suspicious of it." Like Puvis de Chavannes (who went so far as to write to *Le Figaro* denying any connection with the new Salon), Burne-Jones turned down the invitation.

It is very unlikely that Burne-Jones would have accepted or even perhaps understood the label of "Symbolist." Yet to our eyes he seems to have been one of the most representative figures of the Symbolist movement and of that pervasive mood termed "fin-de-siècle."

2. *King Cophetua and the Beggar Maid*, 1880–1884. Oil on canvas, 290 x 136 cm. Trustees of the Tate Gallery, London.

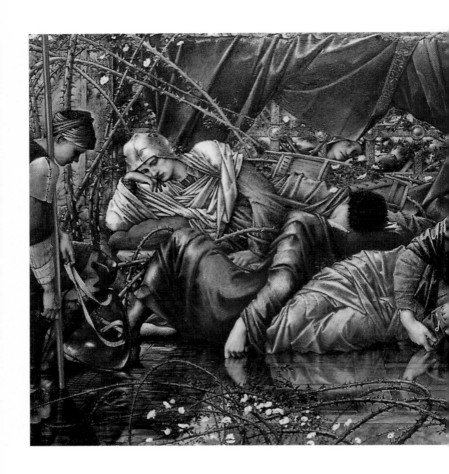

3. *The Briar Rose series: The Council Chamber*, 1870–1890. Oil on canvas, 121.9 x 248.9 cm. Faringdon Collection Trust, Buscot Park.

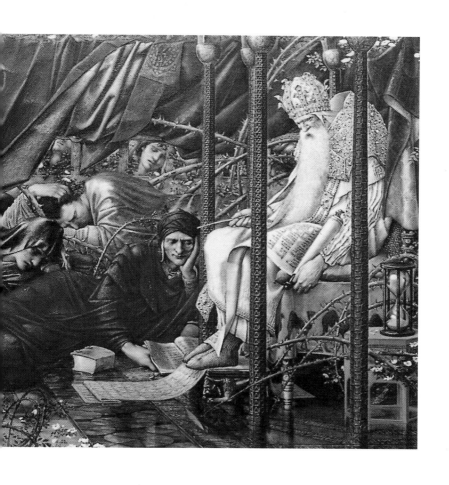

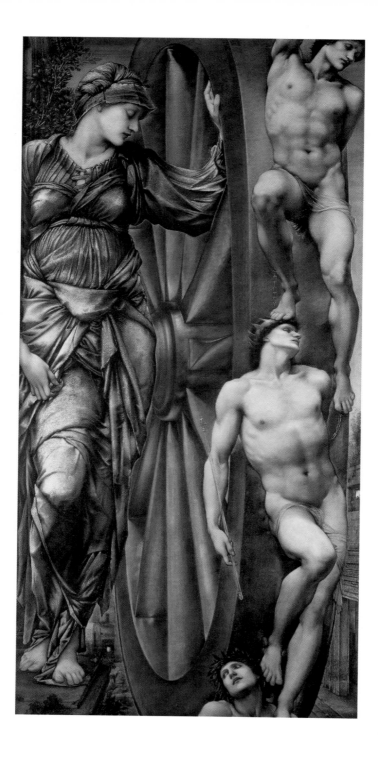

Symbolism was a late-nineteenth-century reaction to the positivist philosophy that had dominated the mid-century and found expression in the gross materiality of the paintings of Courbet and Manet and the realist novels of Emile Zola and in Impressionism with its emphasis on sensory perception. Above all, it was a reaction against the belief in progress and modernity represented by the Eiffel Tower itself and against the triumph of industry and commerce celebrated in the vast "Hall of Machines" in the same exhibition, which had filled Puvis de Chavannes with horror and had given him nightmares.

Burne-Jones' entire life's work can be understood as an attempt to create in paint a world of perfect beauty as unlike the Birmingham of his youth as possible. When Burne-Jones was born in Birmingham in 1831, it was known as the "workshop of the world." Before the exemplary reforms of Mayor Joseph Chamberlain in the late nineteenth century, Birmingham was a byword for the dire effects of unregulated capitalism — a booming, industrial conglomeration of unimaginable ugliness and squalor. The sense of anxiety and alienation that pervades much of Burne-Jones' work and that, despite his yearning for the distant past makes him seem so modern, clearly goes back to his earliest childhood experiences. Like Munch, he could have claimed that sickness and death were the dark angels watching over his cradle.

4. *The Wheel of Fortune*, 1875–1883. Oil on canvas, 200 x 100 cm.
 Musée d'Orsay, Paris.

His mother died within days of his birth and though his father was later affectionate and caring he could not at first bring himself to touch or even look at the child who reminded him of his grief. Burne-Jones (or simply Ned Jones as he was known at this period of his life) grew up a sickly child. According to his wife Georgiana or Georgie, constitutional weakness "must take its place as one of the understood influences of his life." She tells us how later in life he might be found "quietly fainting on a sofa in a room where he had been left alone." This weakness was as much psychological and physical. "With him," according to Georgie, "as with sensitive natures, body and mind acted and reacted on each other." "He could never rid himself of apprehension in life … and was at times worn out by the struggle to meet and endure troubles that never came as well as those that did." Even more than his elaborately wrought paintings, Burne-Jones' humorous drawings, made for the amusement of his friends, reveal the terrors of his inner life with startling frankness.

He shows himself as a hollow cheeked and skeletal neurasthenic, akin to Munch's alter ego in *The Scream* and in comical contrast to the earthy robustness of his life-long friend, William Morris. A particularly telling series of drawings shows him, as he put it, "attempting to join the world of art" by climbing into one of his own paintings and coming out the other side with a bump of disillusion. On the surface, Burne-Jones' private life would seem to have been that of an exemplary Victorian husband and pater familias. He met his future wife Georgiana (Georgie) Macdonald, the sister of a school friend and the daughter of a Methodist minister, when he was nineteen and she was twelve. Despite their humble and impoverished circumstances, the Macdonalds were clearly a very remarkable family.

5. *A Musical Angel*, 1878–1883. Gouache on paper mounted on canvas, 163.2 x 57.8 cm. The Nelson Atkins Museum of Art, Kansas City, Missouri.

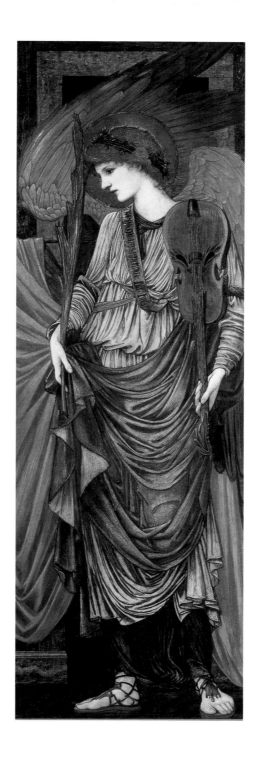

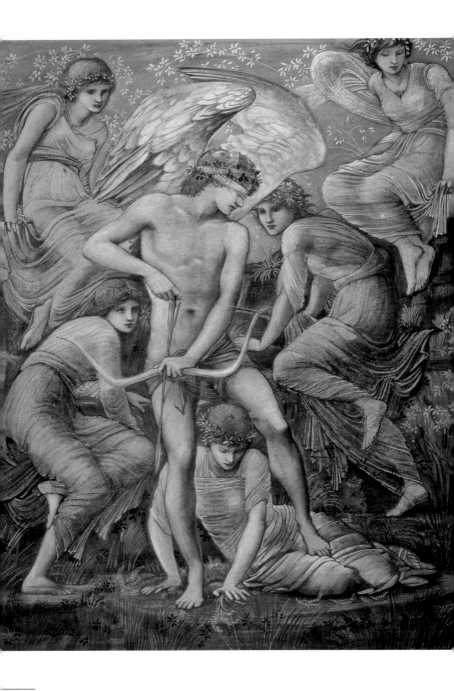

One daughter became the wife of the future president of the Royal Academy, Sir Edward Poynter, and another the mother of the writer Rudyard Kipling. They were generous and open-minded enough to allow their fifteen-year-old daughter to engage herself to a twenty-three-year-old artist of very uncertain prospects. The marriage took place three years later in 1859. It endured until Burne-Jones' death in 1898, after which Georgie devoted herself to writing a monumental two-volume biography of her husband. It is one of the best books of its kind and shows that for all her Victorian wifely abnegation, Georgie was an intelligent and independent minded woman. There were, of course, many things that a Victorian widow could not tell about her marriage and the biography sometimes reveals as much by what it left unsaid as by what is said, but by the standards of the time Georgie's book was remarkably truthful. We sense that this was a marriage that brought her as much frustration and pain as it did fulfilment.

The fact that Burne-Jones fell in love with a girl in her mid-teens, whose slight figure made her look even younger, and that later in life he indulged in intense, if platonic, flirtations with very young girls, suggests that, like his mentor John Ruskin, he probably found it hard to engage emotionally with mature women.

6. *Cupid's Hunting Fields*, 1885. Gouache, 97.2 x 75.2 cm. The Art Institute of Chicago.

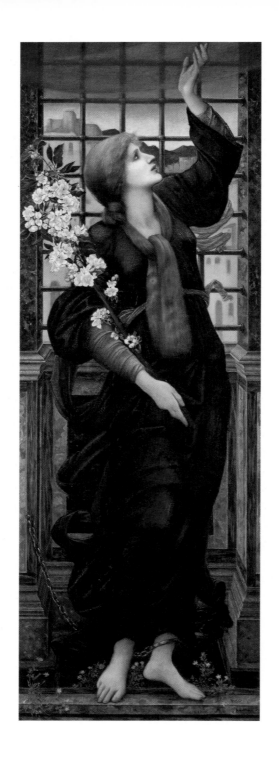

It seems likely that Burne-Jones had no experience of sex before marriage. As Georgie put it delicately when describing Burne-Jones and his young male friends, "I am confident that the mystery which shrouds men and women from each other in youth was sacred to each one of them." Before his marriage, Burne-Jones wrote only half jokingly to his friend Dante Gabriel Rossetti, "I shouldn't be surprised if I bolt off the day before and am never heard of again."

The power of sexual attraction fascinated Burne-Jones and was one of the major themes of his work, but it also filled him with dread. Shortly before he died, Burne-Jones confided to his assistant Thomas Rooke, "Lust does frighten me, I must say. It looks like such despair — despair of any happiness — and search for it in new degradation... I don't know why I've such a dread of lust. Whether it is the fear of what might happen to me if I were to lose all fortitude and sanity and strength — let myself rush downhill without any self-restraint." Burne-Jones was speaking from experience. He knew the cost of losing self-restraint after a disastrous, long running affair with a beautiful Greek woman called Mary Zambaco in the late 1860s and early 1870s that came close to destroying his marriage and his sanity. It was through the wealthy London-based Greek merchant Constantine Ionides (whose remarkable art collection now graces the Victoria and Albert Museum in London) that Burne-Jones was introduced to the strong-willed Euphrosyne Ionides Cassavetti and her exotically beautiful daughter Mary Cassavetti Zambaco. Burne-Jones was commissioned to paint Mary's portrait but also began to use her as a model for his other paintings. Mary was separated from her husband and desperately unhappy. Burne-Jones was always fascinated by female victims and tragic heroines and it was perhaps her unhappiness as much as her beauty that attracted Burne-Jones to Mary Zambaco.

7. *Hope*, 1896. Oil on canvas, 179 x 63.5 cm. Museum of Fine Arts, Boston.

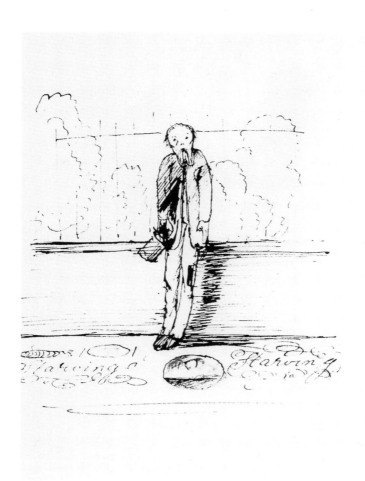

Soon the two were embroiled in a passionate but ultimately doomed affair. Like many a Victorian husband, Burne-Jones could not bring himself to desert his devoted wife and his children and face social disgrace. According to one widely disseminated version of the story, Burne-Jones and Mary Zambaco made a mutual suicide pact but having waded into the waters of the Serpentine, decided that they were too cold and came out again. A more likely account of this incident was given in a somewhat unfeeling letter written by Dante Gabriel Rossetti to the artist Ford Madox Brown: "She provided herself with laudanum for two at least, and insisted on their winding up matters in Lord Holland's Lane. Ned didn't see it, when she tried to drown herself in the water in front of Browning's house etc.- bobbies collaring Ned who was rolling with her on the stones to prevent it, and God knows what else."

According to Gay Daly in her excellent book *Pre-Raphaelite in Love* that dispels or clarifies many myths about the personal lives of the Pre-Raphaelites, what happened next was that Mary and Burne-Jones set off together for the continent. "They didn't get far. Just as he had broken down on the day after his wedding, Ned now got so sick he could not make the Channel crossing. At Dover he came down with what was called brain fever and somehow or other made his way back home, where Georgie put him to bed, called the doctor, and once again took up her role as nurse." According to Rossetti though, Burne-Jones set off with his old friend William Morris in order to escape from Mary. "Poor old Ned's affairs have come to a smash altogether, and he and Topsy (Morris), after the most dreadful to-do started for Rome suddenly, leaving the Greek damsel beating up the quarters of all his friends for him and howling like Cassandra."

8. *Self-Caricature as Pavement Artist*. Pen-and-ink drawing, 11.4 x 6.3 cm. Inscribed "Starving". Courtesy of Sotheby's, London.

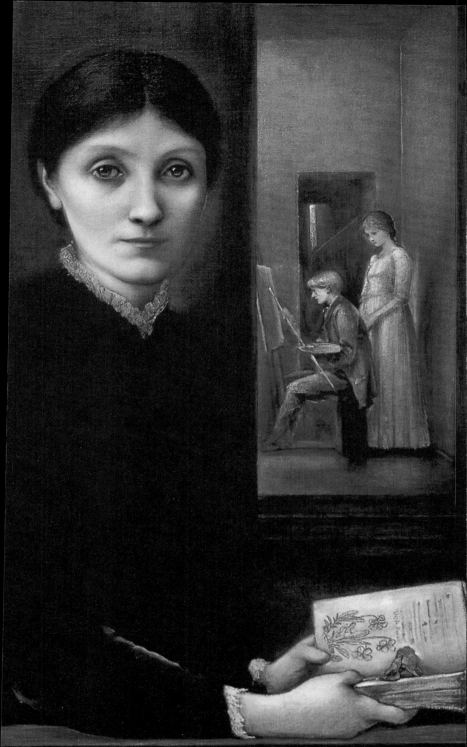

The portraits Burne-Jones made of Mary Zambaco and the pictures inspired by her or for which she posed are infused with a carnal intensity that is quite exceptional in his work. A gouache portrait Burne-Jones made of Mary in 1870 is in effect an open declaration of his love for her. A sad-faced Cupid draws aside a deep-blue curtain, to reveal Mary looking equally downcast. Her hands rest on the open pages of an illustrated book with Burne-Jones' *Le Chant d'Amour* clearly visible.

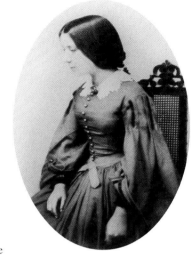

In the foreground pointing towards the book is an arrow wrapped in a scroll inscribed "Mary Aetat XXVI August 1870 EPJ pinxit" (Mary aged 26 August 1870 painted by EBJ). The painterly treatment of the richly coloured fabrics with boldly scumbled highlights gives the painting a Venetian air, but the broodingly oppressive sensuality and the way the piled up mass of Mary's dark hair seems to weigh her down, recall, or rather anticipate Dante Gabriel Rossetti's portraits of his last great love, Jane Morris. One wonders where Burne-Jones painted this picture and how he managed to conceal it from Georgie.

9. *Georgiana Burne-Jones*, 1883. Oil on canvas, 73.7 x 53.3 cm. Private collection.

10. Georgiana Macdonald at age sixteen. Black-and-white photograph by Walker E. Cockerell. From Georgiana Burne-Jones, *Memorials of Edward Burne-Jones* (London, 1904). By courtesy of the National Portrait Gallery, London.

Even more erotically charged than the gouache is a lovely pencil portrait of Mary made at around the same time. The down-angled viewpoint and the close-up format with her face and upper body filling most of the sheet, convey the intimacy between the artist and his model. Her luxuriant hair spreads out tendril-like over the cushions, creating the effect of a fiery halo and anticipating countless similar images of women's hair by fin-de-siècle artists such as Toorop, Mucha and Munch.

In the early 1870s, Burne-Jones painted several mythical or legendary pictures in which he seems to have been trying to exorcise the traumas of his affair with Mary Zambaco. *Phyllis and Demophoon* also known as *The Tree of Forgiveness* shows the Queen of Thrace who hanged herself after her lover Demophoon failed to keep his promise to return to her. She was transformed into a tree and when Demophoon finally did return she reached out from the tree to embrace him as depicted by Burne-Jones. Demophoon recoils with an expression of guilty dread. As depicted by Burne-Jones, the subject seems to refer with astonishing directness to the most painful and humiliating episode in his affair with Mary — her suicide threats and their unseemly wrestling match on the banks of the Regent's Canal. It seems extraordinary that an artist, who had hitherto been so reluctant to show his work in public, should choose to show such a revelatory work at the Old Water Colour society in 1870 when his affair was not yet over. It was almost as if he needed to expose his guilt and his shame to the world. Burne-Jones was deeply mortified when he was asked to remove the picture from the walls of the exhibition on grounds of decency. It was apparently the exposed male genitalia that caused offence. Burne-Jones followed the custom going back to the ancient world of depicting the male genitalia as of pre-pubescent size and harmlessness.

11. *Cupid Finding Psyche*, 1865–1887. Watercolour, gouache with golden painting, 69.4 x 49.4 cm. Manchester City Art Galleries.

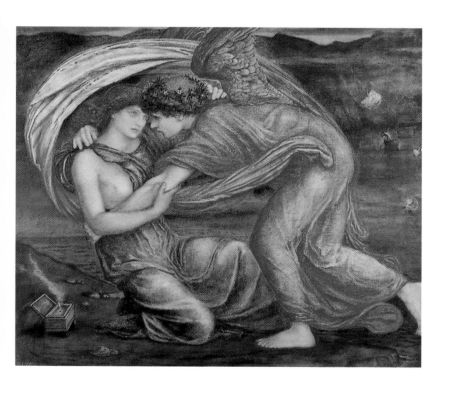

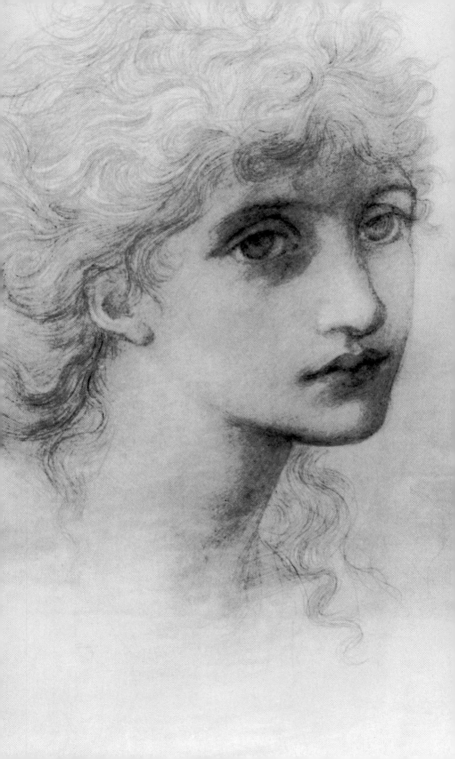

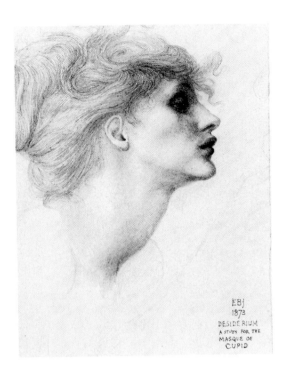

EBJ
1873
DESIDERIUM
A STUDY FOR THE
MASQUE OF
CUPID

12. *Drawing of Mary Zambaco*, 1871. Pencil, 26.7 x 21.6 cm. Courtesy of Sotheby's, London.

13. *Desiderium*, 1873. Pencil, 21 x 13.3 cm. Tate Gallery, London.

Even this seems to have been too much for prudish Victorian sensibilities or perhaps that rumours circulating about Burne-Jones' private life had alerted the exhibition organisers to the secret meaning of Burne-Jones' picture.

A second picture of the early 1870s *Pan and Psyche* also seems to refer obliquely to the Regent's Canal incident. It shows Psyche being comforted tenderly by Pan after an abortive attempt to drown herself in the belief that she had been rejected by Cupid. The shaggy legged satyr, half goat and half man, no doubt symbolises the animal and sensual side of Burne-Jones' own nature as it does of mankind in general in Greek mythology. If *Phyllis and Demophoon* and *Pan and Psyche* both present Mary in disguised form as a helpless victim, the tables are turned in another important work that deals in thinly veiled fashion with the relationship of Mary Zambaco and Burne-Jones, *The Beguiling of Merlin*. Begun in 1873 when the affair was already finished and Mary Zambaco had taken herself off to Paris, it can be regarded as Burne-Jones' epitaph on their love. Drawn from the Arthurian legends that provided Burne-Jones with so much inspiration throughout his career it relates how the nymph Nimue casts a spell on the wizard Merlin (with whom Burne-Jones identified himself on more than one occasion) and imprisoned his sleeping form within a hawthorn tree for all time.

14. *The Depths of the Sea*, 1886. Oil on canvas, 197 x 75 cm. Private collection.

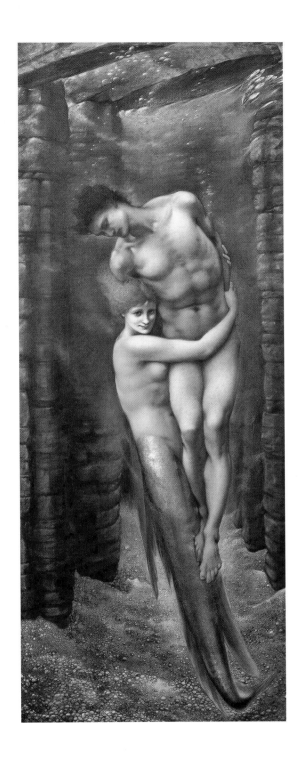

Explaining the picture in a letter written many years later, Burne-Jones was candid about its autobiographical content: "The head of Nimue was painted from the same poor traitor and was very like — all the action is like — the name of her was Mary. Now isn't that very funny as she was born at the foot of Olympus and looked and was primeval and that's the head and the way of standing and turning... I was being turned into a hawthorn bush in the forest of Broceliande — every year when the hawthorn buds it is the soul of Merlin trying to live again in the world and speak — for he left so much unsaid."

After the near catastrophe of his affair with Mary Zambaco, Burne-Jones confined himself for the rest of his life to a series of sentimental but it seems, purely platonic relationships with attractive and well-bred young girls who also served as models and inspiration for his art. The first in the series was Frances Horner, the daughter of William Graham, one of Burne-Jones' most faithful collectors. He wrote to her harmlessly enough, "How blessed it must be to look in the glass and see you." In return she declared, "He was my greatest friend of all my grown-up life."

Frances Horner can be recognised along with several other of Burne-Jones' young lady friends processing down the spiral staircase in *The Golden Stairs* as they followed one another through the artist's life. One of the last of Burne-Jones' friendships with younger women, that with Helen Gaskell, seems to have gone beyond the strict rules of propriety required for friendships between the sexes in Victorian England. Letters show that once again Burne-Jones' passion brought him to the brink of a momentous decision to leave Georgie.

15. *Mary Zambaco*, 1870. Gouache, 76.3 x 55 cm. Clemens-Sels-Museum, Neuss (Germany).

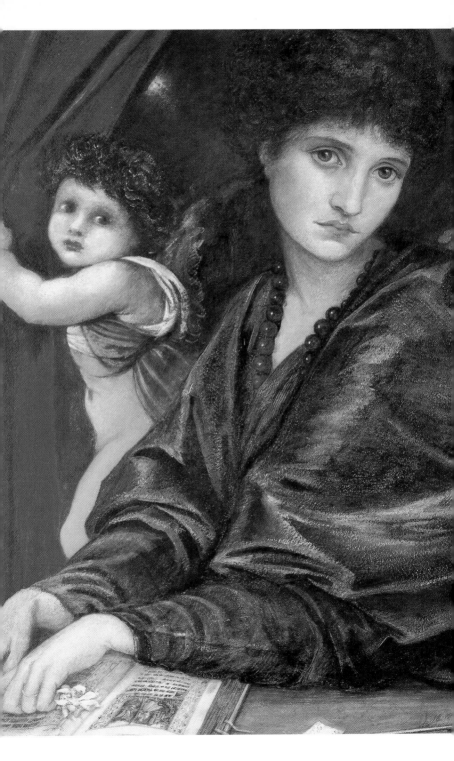

Burne-Jones is usually labelled as a Pre-Raphaelite, but in fact he was never a member of the Pre-Raphaelite Brotherhood formed in 1848 by William Holman Hunt, John Everett Millais, Dante Gabriel Rossetti, and four of their friends, nor does his art have much to do with the kind of Pre-Raphaelitism practised by Hunt and Millais the early years of the brotherhood.

A comparison of Hunt's *The Awakening Conscience* and Burne-Jones' *King Cophetua and the Beggar-Maid*, both of which seem representative of their respective creator's attitudes to art and life, shows just how far apart they were. Both paintings concern the relations of the sexes, but in every other respect they are utterly polarised.

The Awakening Conscience deals with the contemporary problem of the "fallen woman" in the most uncompromisingly, documentary fashion. Hunt rented a room at Woodbine Villa, 7 Alpha Place, St. John's Wood (an area of London then notorious for "kept women") in order to give the most specific and accurate setting possible to this scene of modern depravity. The "fatal newness of the furniture," as Ruskin put it, is recorded mercilessly, as is the ugliness of the rosewood piano, which would certainly have repelled Burne-Jones and Morris who put so much effort into designing aesthetically acceptable pianos.

16. *Phyllis and Demophoon*, 1870. Watercolour and gouache, 91.5 x 45.8 cm. Birmingham Museums and Art Gallery.

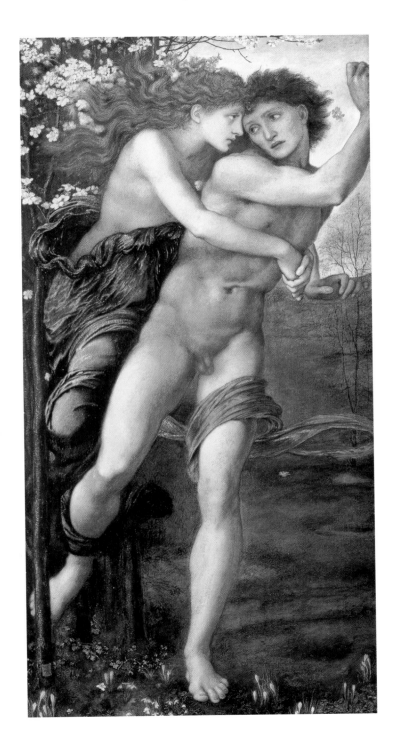

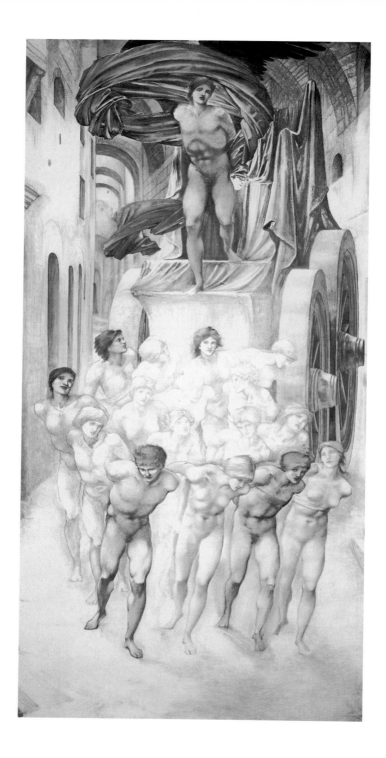

Burne-Jones put as much effort into removing his scene from time and place as Hunt did in creating a specific setting. He did not want King Cophetua's armour to look like that of any particular period, so he studied armour until he felt that he understood the principles of armour making well enough to design his own. The result is quite extraordinary — a strange, organic, proto-art nouveau, body hugging armour that looks as though it was made of plastic or leather rather than of metal. Burne-Jones also agonised over the elegant designer rags worn by the beggar-maid, wanting them to look "sufficiently beggarly" but at the same time perfectly beautiful.

In a letter of 1883, he wrote that he hoped that this had been achieved so that "she shall look as if she deserved to have it made of cloth of gold and set with pearls. I hope the king kept the old one and looked at it now and then." Hunt's repentant whore starts up with a fleeting expression of revelation on her face, (Hunt modified the expression at the request of the first owner) while her callous lover sings on unaware of her transformation. This theatrical use of facial expression would have been an anathema to Burne-Jones who said, "The moment you give what people call expression you destroy the typical character and degrade them into portraits which stand for nothing." The beggar-maid stares forward fixedly. Her stance and her absence of facial expression convey a vague sense of ill ease and dread. This princess of hearts, a simple girl destined to be the wife of a king, could be bulimic. Her bruised eyes and her unhealthy pallor are the fin-de-siècle equivalent of "heroin chic." In Burne-Jones' view "A painter who moralises gives up his proper metier of creating beauty."

17. *The Car of Love*, 1872. Oil on canvas, 457.2 x 182.9 cm. Victoria and Albert Picture Library, London.

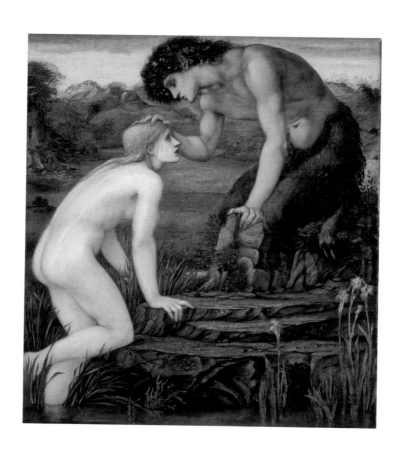

18. *Pan and Psyche*, circa 1872–1874. Oil on canvas, 61 x 54.6 cm.
Private collection.

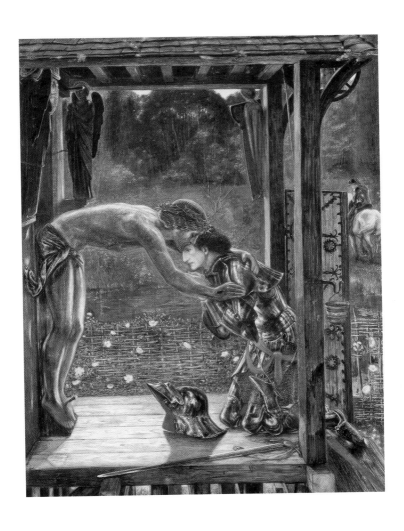

19. *The Merciful Knight*, 1863. Watercolour and gouache, 100.3 x 69.2 cm. Birmingham Museums and Art Gallery.

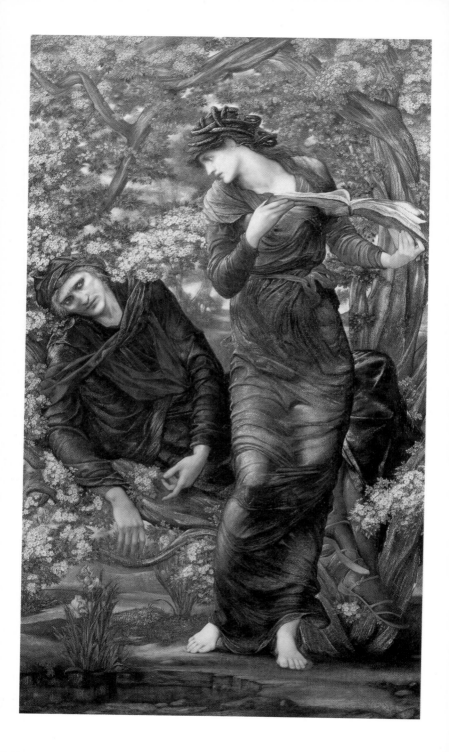

Hunt's picture with its social conscience and Victorian moralising worn on its sleeve, its glossy, hard-edged technique and its pedantic recording of harsh, material reality, represents everything that Burne-Jones turned his back on.

Burne-Jones' brand of Pre-Raphaelitism derives not from Hunt and Millais but from Dante Gabriel Rossetti. Already in the 1850s Rossetti lost patience with the painstaking truth to nature of his two friends. *Found*, his one attempt at social realism in the manner of Hunt (yet another depiction of a repentant fallen woman) was never to be completed. Instead, Rossetti began making gouaches of legends, dreams and literary themes that are amongst his loveliest works. Though highly detailed, they are flat and abstracted. More often than not they evoke a mood rather than telling a story. With hindsight, we can see this flatness and the turning away from narrative as characteristics of early modernism and the first hesitant steps towards abstraction. It is not as odd as it might seem that Kandinsky cited Rossetti and Burne-Jones as forerunners of abstraction in his book *Concerning the Spiritual in Art*. While still at Oxford in the mid-1850s the discovery of Rossetti's *The Maids of Elfenmere*, an engraved illustration to a poem by William Allingham, came as a revelation that changed the course of Burne-Jones' career. According to Georgiana Burne-Jones it was possible to discern at first glance which drawings Burne-Jones made before and which he made after his first sight of *Maids of Elfenmere*.

20. *The Beguiling of Merlin*, 1874–1876. Oil on canvas, 186 x 111 cm. Lady Lever Art Gallery, Wirral (UK).

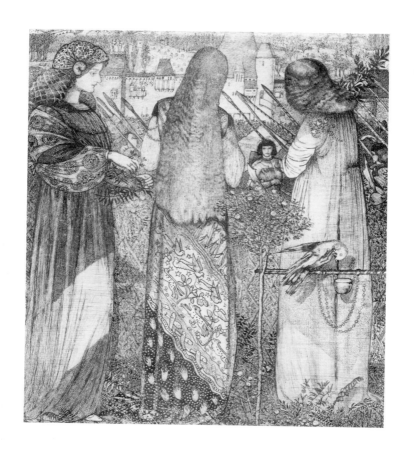

21. *Going to the Battle*, 1858. Grey pen-and-ink drawing on vellum paper, 22.5 x 19.5 cm. Syndics of the Fitzwilliam Museum, Cambridge.

22. *The Golden Stairs*, 1876–1880. Oil on canvas, 269.2 x 116.8 cm. Tate Gallery, London.

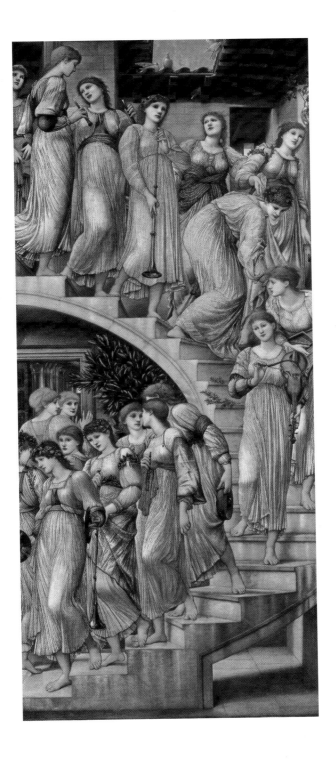

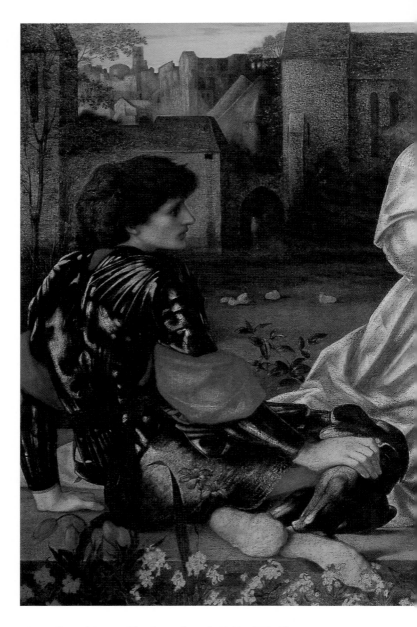

23. *Le Chant d'Amour* (*The Song of Love*), 1868–1877. Oil on canvas, 114.3 x 155.9 cm. The Metropolitan Museum of Art, New York.

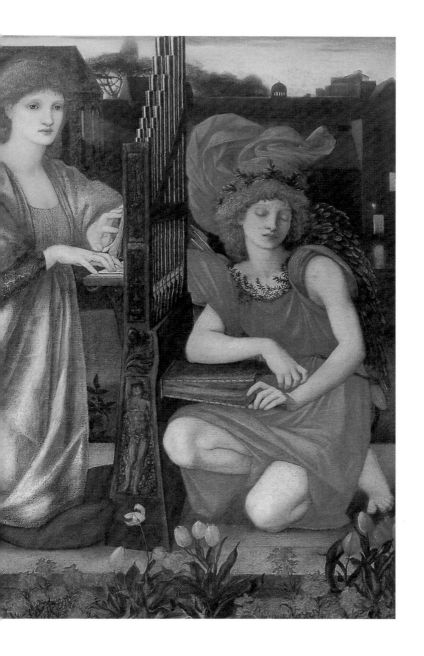

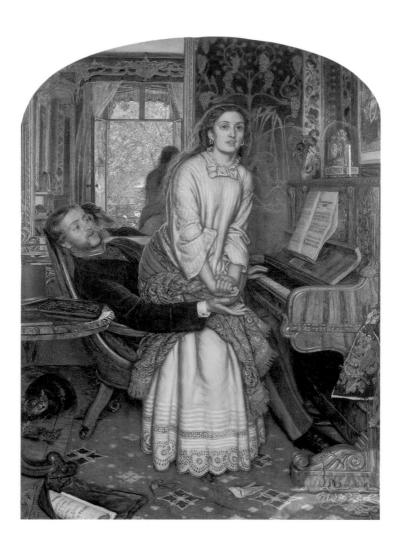

When Burne-Jones finally met Rossetti in the winter of 1855 at the workingmen's club in Great Titchfield Street, it was an experience akin to falling in love. Soon after he wrote to a friend, "…and then Lushington whispered to me that Rossetti had come in, and so I saw him for the first time, his face satisfying all my worship, and I listened to addresses no more, but had my fill of looking…" It was a worship that never diminished despite Rossetti's later descent into alcoholism, drug abuse and paranoia. Later in life Burne-Jones said of Rossetti, "There is more than any tenderness of friendship in what I feel for him. He is the beginning of everything in me that I care for."

Burne-Jones' work in the late 1850s is closely based on Rossetti's style. His feminine ideal is also taken over by that of Rossetti, with abundant hair, prominent chins, columnar necks and androgynous bodies hidden by copious medieval gowns. They differed on the question of the colour of women's hair. "Rossetti used to persuade me to paint from red-haired women and I did without anything in particular happening … when I see red hair I like it. Rossetti's pictures of red-headed women I like exceedingly but I don't think red hair does well with my own work." The prominent chins remain a striking feature of both artists' depiction of women, only to be mercilessly caricatured by Beardsley and Max Beerbohm. From the 1860s their ideal types diverge. As Rossetti's women balloon into ever more fleshy opulence, Burne-Jones' become more virginal and ethereal, to the point that in some of the last pictures, such as *The Wedding of Psyche* of 1894-1895, the girls look anorexic. Already in *Le Chant d'Amour* (the watercolour dating from 1865 and the oil version begun in 1868) and *The Mill* (begun in 1870) we find all those features in Burne-Jones' work that we would characterise as "fin-de-siècle" and Symbolist, long before either term had come into common usage.

24. William Holman Hunt, *The Awakening Conscience*, 1853. Oil on canvas, 76.2 x 55.9 cm. Tate Gallery, London.

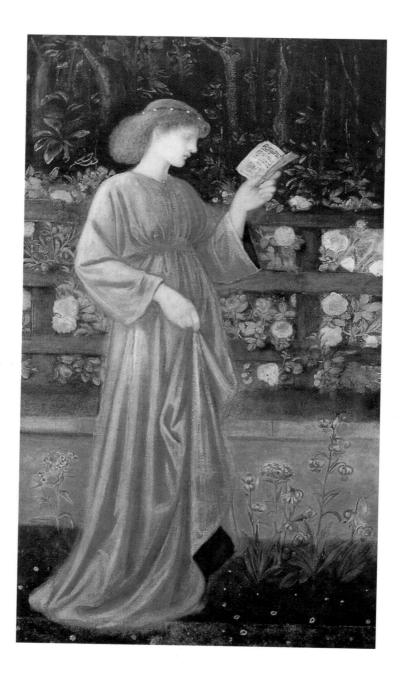

25. *The King's Daughter*, 1865–1866. Oil on canvas, 107 x 67 cm. Musée d'Orsay, Paris.

26. *Cupid and Beauty*, 1874. Pencil, 89 x 118 cm. Private collection.

Though *Le Chant d'Amour* refers to Giorgione's *Concert Champêtre* in the Louvre (which two years earlier had provided inspiration for the very different *Déjeuner sur l'Herbe* of Manet) its point of departure is the series of small gouaches of medieval subjects executed in the 1850s by Rossetti, such as *The Blue Closet*, that concentrated on the evocation of a poetic mood rather than on the telling of stories. Like *The Blue Closet*, *Le Chant d'Amour* depicts music making. The idea of painting "unheard melodies" was important to both Rossetti and Burne-Jones. They were fascinated by the way that music can express mood and emotion by purely abstract means and they desired that painting should be able to assume the same powers. The two aspects of *Le Chant d'Amour* and other pictures like it that seem so fin-de siècle are the languor of the figures (what Gustave Moreau would have termed "La Belle Inertie" or beautiful inertia) and the blurring of gender.

Apart from the somewhat paler complexion of the young woman who plays the organ, her head could easily be transposed with that of the languid knight on the left without noticing the difference and the young person who works the bellows of the organ is of alto-gether indeterminate sex. In the last quarter of the nineteenth century, the cult of the androgyne, a type combining the beauty of both sexes, became a central theme of Symbolist art and literature. In his groundbreaking book *The Romantic Agony*, Mario Praz commented on the paintings of Moreau: "Lovers look as though they were related, brothers as though they were lovers, men have the faces of virgins, virgins of youths. The symbols of good and evil are entwined and equivocally confused. There is no contrast between different ages, sexes or types. The underlying meaning of the painting is incest, its most exalted type the androgyne, its final word is sterility." It is a description that could apply equally well to the work of Burne-Jones.

27. *The Perseus Series: Perseus and the Sea Nymphs (The Arming of Perseus)*, 1877. Gouache, 152.8 x 126.4 cm. Southampton City Art Gallery.

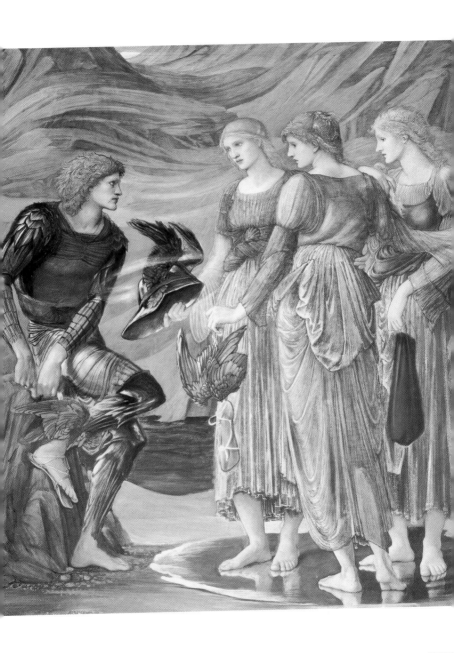

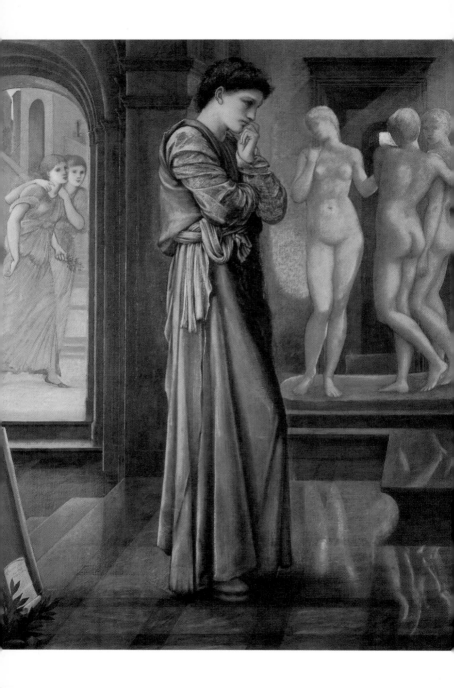

The Mill, begun in 1870 but not shown until 1882, is an even more elusive work. Its title gives us no help at all in trying to penetrate its many levelled meanings. In the foreground, three young women perform a solemn, hieratic dance, accompanied by a musician of uncertain gender. The central of the three dancers engages the viewer with an ambivalent and teasing expression. Behind the dancers, on the other side of a dank canal, we see a group of beautiful nude young men who seem to have escaped from the Sistine ceiling for an afternoon of swimming. Stretching across the background is a strange townscape of the mind, with architecture that looks back to Rome and the Middle Ages and forward to Voysey and Mackintosh, staircases, doorways and bridges that lead to nowhere.

Close study of the picture surface beneath the protective plate glass favoured by Burne-Jones (one innovation of the industrial age he did not reject) reveals elaborately wrought surface textures with an embossed pattern of stylised foliage underneath the green of the foreground. "I love my picture as a goldsmith does his jewels," he Close study of the picture surface beneath the protective plate glass favoured by Burne-Jones (one innovation of the industrial age he did not reject) reveals elaborately wrought surface textures with an embossed pattern of stylised foliage underneath the green of the foreground. "I love my picture as a goldsmith does his jewels," he said. "I should like every inch of surface to be so fine that if all but a scrap from one of them were burned or lost, the man who found it might say – whatever this may have represented, it is a work of art beautiful in surface and quality of colour."

This love of precious and elaborately worked paint surfaces was another thing that Burne-Jones shared with Gustave Moreau who termed it "la Richesse Nécessaire."

28. *Pygmalion and the Image I: The Heart Desires*, 1875–1878. Oil on canvas, 99.1 x 76.2 cm. Birmingham Museums and Art Gallery.

The emphasis on beauty of surface and colour separate from representation anticipated Maurice Denis' famous dictum: "Remember that before it is a war horse, or a naked woman or a trumpery anecdote, a painting is essentially a flat surface, covered with colours assembled in a certain order."

The oat-coloured hair and mysterious expression of the central dancer in *The Mill* identify her as one of those "exceedingly mischievous" women for whom Burne-Jones had a declared fondness. He divided the women he liked to paint into two categories: "the very good, the golden-haired, and the exceedingly mischievous, the sirens with oat-coloured hair." Burne-Jones painted more female victims than predators, but his experience with Mary Zambaco had taught him that even victims are not without their dangers. He told his studio assistant Thomas Rooke, "There's a self-contradiction in pitying a woman – the worst of it is that as soon as you've taken pity on her, she's no longer to be pitied. You're the one to be pitied. So beware."

Some of Burne-Jones' statements about women would doubtless offend twenty-first century canons of political correctness: "A woman at her best, self-denying and devoted, is pathetic and lovely beyond words, but once she gets the upper hand and flaunts, she is the devil – there's no other word for it; she is the devil." But Burne-Jones never shared the virulent misogyny of Moreau, Rops, Munch and many other artists and writers of the fin-de-siècle. The more carnal femmes fatales, such as Salome, Judith and Delilah, did not appeal to him as subject matter. The most striking depiction of an evil woman in his early career is *Sidonia von Bork*, a gouache of 1860 based on Johann Wilhelm Meinhold's novel *Sidonia the Sorceress*.

29. *Pygmalion and the Image II: The Hand Refrains*, 1875–1878.
 Oil on canvas, 99.1 x 76.2 cm. Birmingham Museums and Art Gallery.

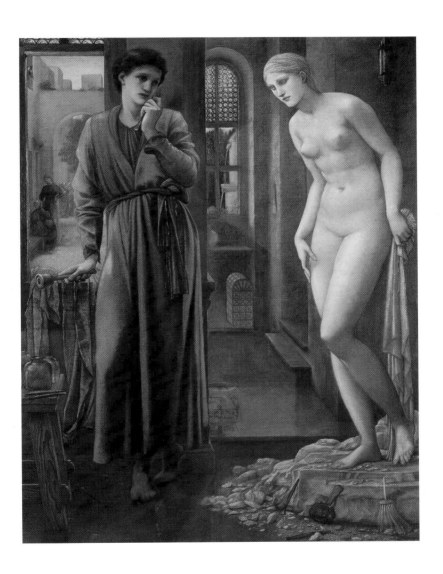

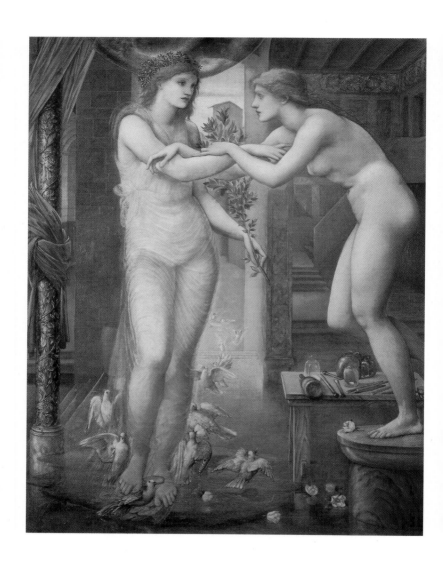

30. *Pygmalion and the Image III: The Godhead Fires*, 1875–1878.
 Oil on canvas, 99.1 x 76.2 cm. Birmingham Museums and Art Gallery.

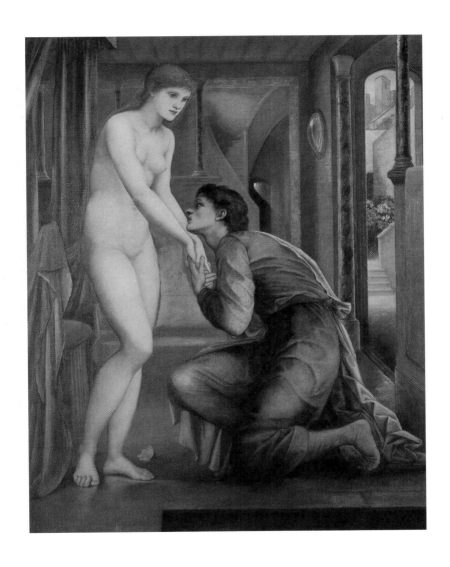

31. *Pygmalion and the Image IV: The Soul Attains*, 1875–1878.
Oil on canvas, 99.1 x 76.2 cm. Birmingham Museums and Art Gallery.

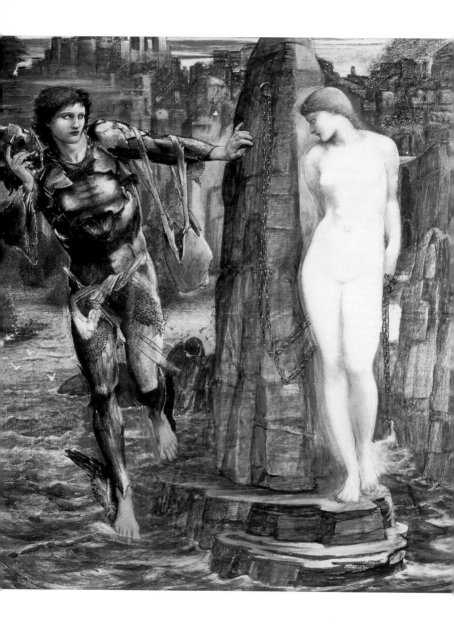

This picture owes a double debt to an earlier gouache by Rossetti of Lucrezia Borgia washing her hands after disposing of one of her husbands by poison and to Giulio Romano's famously sinister portrait of Isabella d'Este from which Burne-Jones has borrowed the interweaving, linear pattern on the dress that so effectively suggests the web of murderous intrigue spun by the evil Sidonia.

Laus Veneris, exhibited at the Grosvenor Gallery in 1878, was Burne-Jones most sumptuous and ambitious treatment of the femme fatale theme. The story of how Venus, the goddess of love in classical mythology, was transformed into an enchantress in medieval legend and used her ancient powers to entrap Christian knights, held a powerful appeal for the nineteenth century and had already inspired Wagner, William Morris and Swinburne before Burne-Jones painted this, his second version of the subject. The languid hothouse eroticism of Burne-Jones' picture is closest to Swinburne's poem of the same title that had been published in 1866 in the volume *Poems and Ballads* that was dedicated by Swinburne to Burne-Jones. The critic Frederick Wedmore was repelled by the "unhealthy" atmosphere of the picture: "*Laus Veneris* is an uncomfortable picture, so wan and death-like, so stricken with disease of the soul, so eaten up and gnawed away with disappointment and desire, is the Queen of Love at the Grosvenor... The type is to many an offensive, to most a disagreeable one, and the Venus is of that type the most disagreeable, the most offensive example.

32. *The Perseus Series: The Rock of Doom*, circa 1884–1885.
 Gouache, 154 x 128.6 cm. Southampton City Art Gallery.

The very body is unpleasant and uncomely, and the soul behind it…
ghastly." Even Henry James, normally a warm supporter of the artist
was mildly sceptical, commenting that Venus "has the face and
aspect of a person who has had what the French call an "intimate"
acquaintance with life; her companions, on the other hand, though
pale, sickly and wan, in the manner of all Mr. Burne-Jones' young
people, have a more innocent and vacant expression, and seem to
have derived their languor chiefly from contact and sympathy."

Fin-de-siècle languor is taken to its ultimate extreme in *The Briar
Rose* series, arguably Burne-Jones' greatest and most characteristic
masterpiece. The series retells the familiar story of sleeping beauty,
drawn from the fairy-tale of Charles Perrault. Burne-Jones treated
the subject at least three times, the definitive version being the
great series painted between 1874 and 1890, which is now at
Buscot Park. Another artist in another epoch would most probably
have depicted the moment of awakening but Burne-Jones chose to
show the whole world plunged into deepest slumber. Only the
prince about to enter the enchanted world is still awake and even
he looks so tired that we are not sure he will ever make it across
four panels to the sleeping princess.

For his depiction of the princess on her bier-like bed, Burne-Jones
used his beloved daughter Margaret as a model. The series can be
interpreted as an allegorical treatment of Margaret's sexual awakening.

Page 55:
33. *The Seasons: Spring*, 1869. Gouache, 122.6 x 44.9 cm. Private Collection.

Page 56:
34. *The Seasons: Summer*, 1869. Gouache, 122.6 x 44.9 cm.
 Private Collection.

Page 57:
35. *The Seasons: Autumn*, 1869. Gouache, 122.6 x 44.9 cm.
 Private Collection.

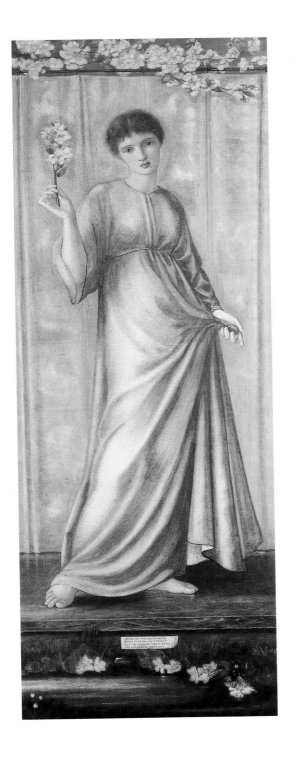

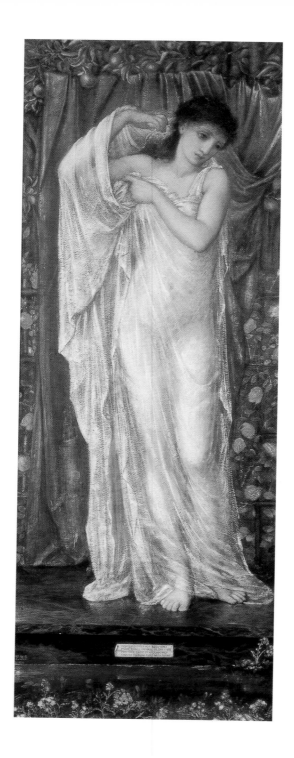

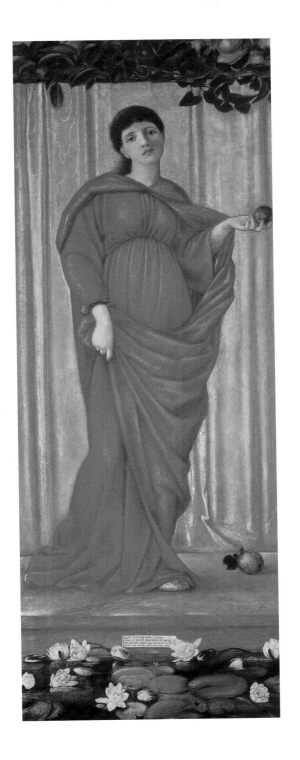

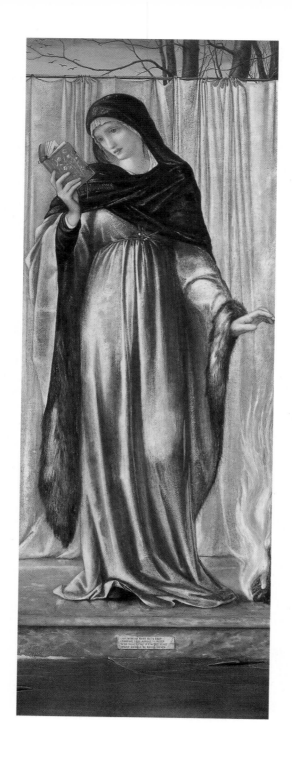

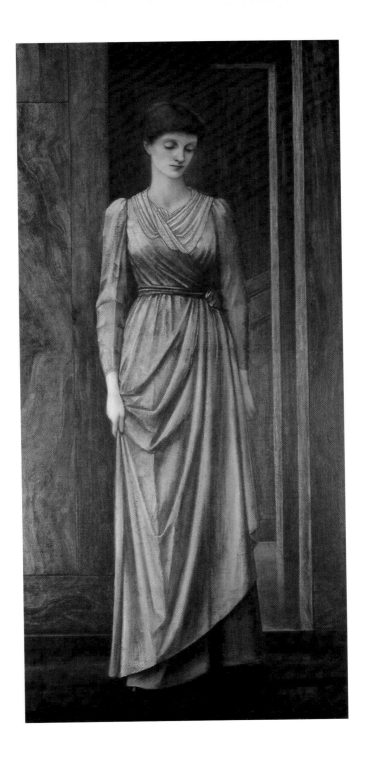

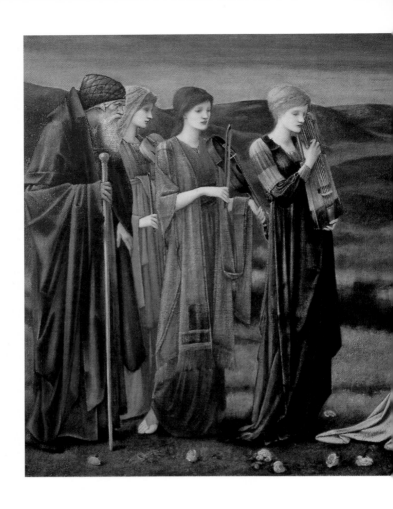

Page 58:
36. *The Seasons: Winter*, 1869. Gouache, 122.6 x 44.9 cm. Private Collection.

Page 59:
37. *Lady Windsor*, 1893–1895. Oil on canvas, 199.5 x 95.5 cm.
 Collection Viscount Windsor.

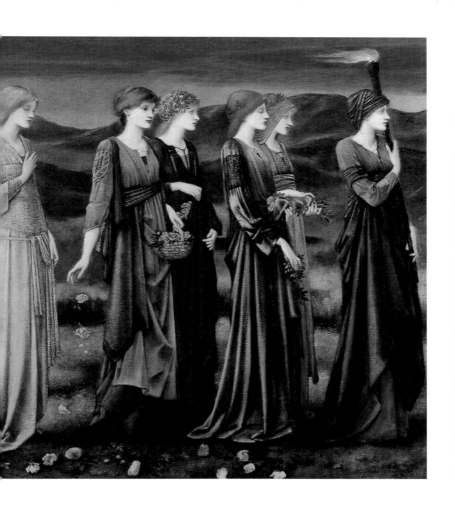

38. *The Wedding of Psyche*, 1895. Oil on canvas, 122 x 213.4 cm.
Musées Royaux des Beaux Arts de Belgique, Brussels.

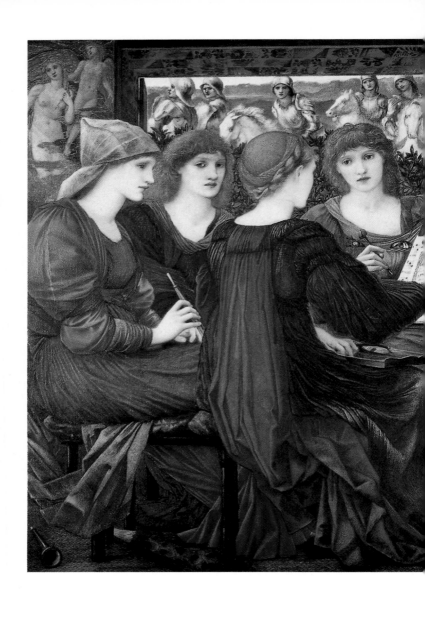

39. *Laus Veneris*, 1878. Oil on canvas, 122.6 x 183.2 cm. Laing Art Gallery, Newcastle-upon-Tyne (UK).

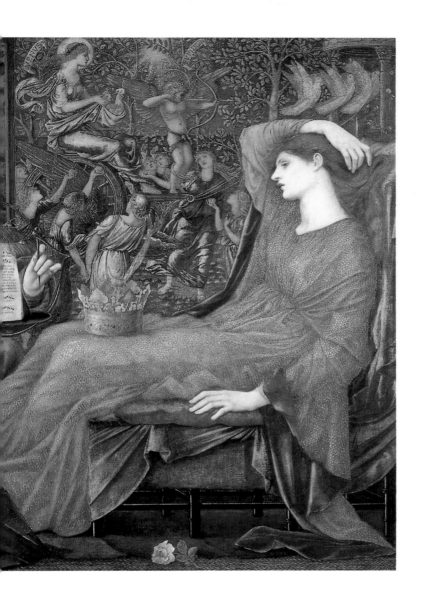

In 1888, two years before the completion of the series, Burne-Jones was deeply disconcerted and disturbed when his daughter became engaged to John W. Mackail. He announced the event to his old friend George Frederick Watts in mock tragic tones that do not fully disguise his very real perturbation: "My little is engaged.

I haven't felt very good about it – I have behaved better than I felt. She looks very happy, and before he wanted her, and before I dreamt of any such thing, I thought him a fine gentleman through and through, and yet, look what he has done to me! I have known him for seven years, and always he seemed a grave and learned man who came to talk to me about books – and it wasn't about books he came, and now where am I in the story? Send her a little blessing, for she loves you both – and say nothing consoling to me, for I have in me no bit of wisdom or philosophy, or ever had or shall have."

In the first large panel the prince enters a wood in which knights clad in Burne-Jones' sexily body-hugging organic armour loll in poses suggestive of post-coital exhaustion. A study for the scene showing the knights nude is even more sensuous and makes a striking comparison with the orgiastic carnage in the foreground of Gustave Moreau's vast canvas *The Suitors*. Like Burne-Jones, Moreau was in the habit of using myth and legend to exorcise psychological demons and express sexual fantasies. Moreau's picture is based on the story of Ulysses' return to Ithaca after many years of wandering.

Page 65:
40. *The Briar Rose: Study for "The Garden Court"*, 1889.
 Gouache, 91.2 x 60.6 cm. Birmingham Museums and Art Gallery.

Page 66–67:
41. *The Lament*. 1866. Watercolour and gouache on paper mounted on
 canvas, 47.5 x 79.5 cm. William Morris Gallery, Walthamshow (UK).

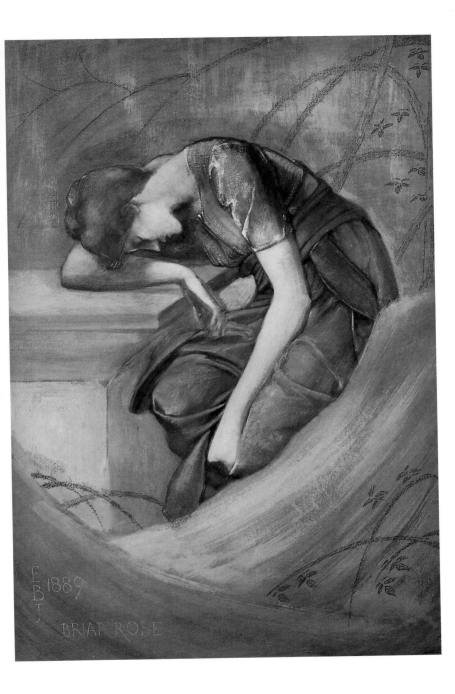

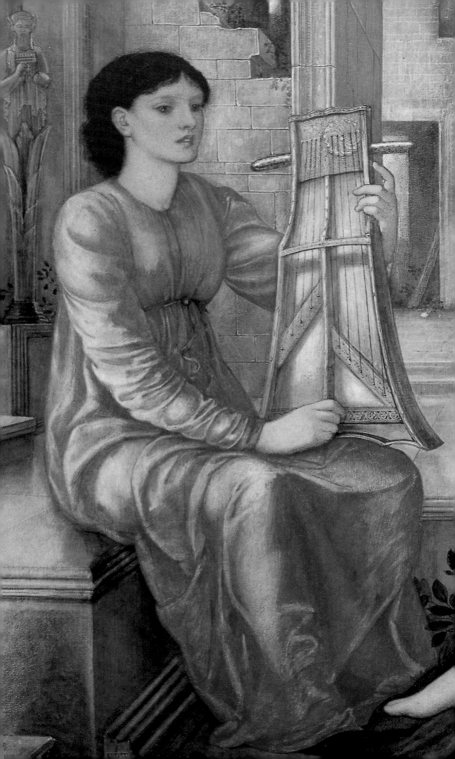

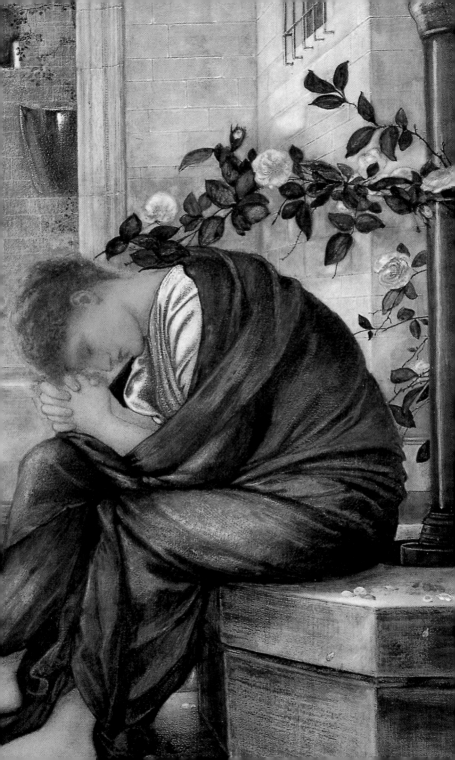

He massacres the fifty suitors who have been pressing their unwanted attentions on Ulysses' faithful wife Penelope. The beautiful and effeminate young men dressed in scant and frilly costumes that look as though they have been raided from the props cupboard of the Folies Bergère, fall into attitudes of sexual abandon as they are pierced from behind by Ulysses' arrows.

It is hard to believe that any of them could have been the least bit interested in Penelope. Burne-Jones' lifelong history of falling desperately in love with beautiful young women leaves little doubt about his predominantly heterosexual nature, but the effeminate beauty of his male figures and his intense friendship with the poet Algernon Swinburne and the painter Simeon Solomon in the late 1860s inevitably raise some questions about his underlying sexuality. Burne-Jones was certainly very susceptible to male beauty. When he saw the handsome Polish pianist Jan Paderewski in 1893 he suffered a "coup de foudre" almost as intense as many caused by the sight of young female "stunners" over the years. He wrote, "There's a beautiful fellow in London named Paderewski – and I want to have a face like him and look like him, and I can't – there's the trouble.

He looks so like Swinburne looked at twenty that I could cry over past things, and has his ways too – the pretty ways of him – courteous little tricks and low bows and a hand that clings in shaking hands... I praised Allah for making him and felt myself a poor thing for several hours. Have got over it now!" An early work with decidedly homoerotic undertones is *The Merciful Knight*, which shows a nude sculpture of the crucified Christ leaning down from the cross to embrace a praying knight. The imagery echoes that of Spanish Baroque paintings of nude muscular Christ figures such as Murillo's *St. Francis Embracing the Crucified Christ* and Ribalta's *Christ Embracing St. Bernard*, though Burne-Jones who dismissed all Spanish art as "beastly" was probably unaware of these Spanish precedents.

42. Dante Gabriel Rossetti, *The Blue Closet*, 1857. Watercolour on paper, 34.6 x 26 cm. Tate Gallery, London.

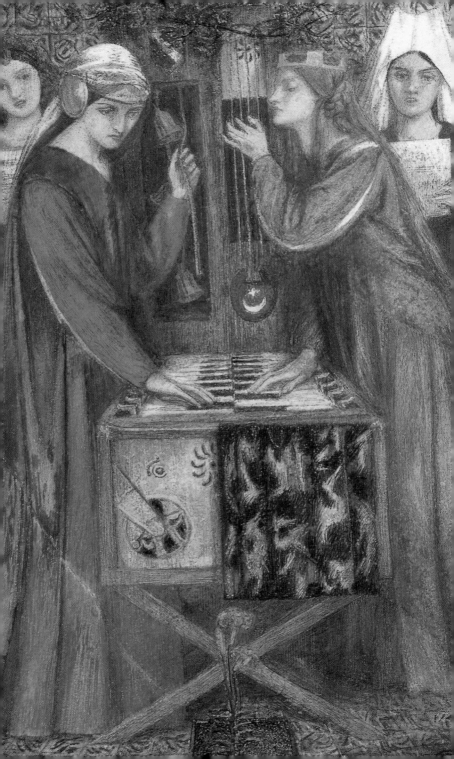

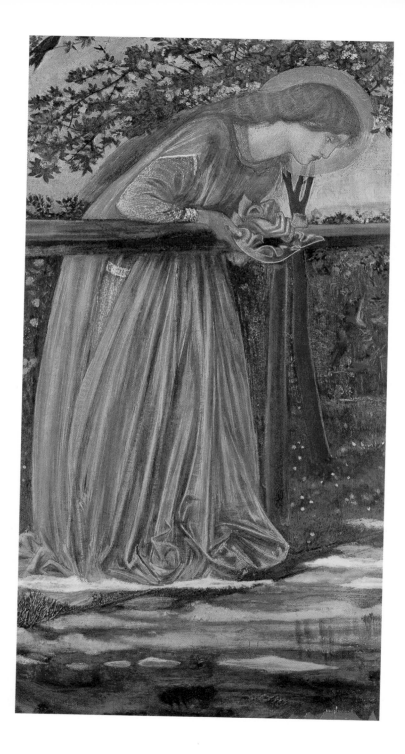

The Merciful Knight was intensely disliked when it was first shown at the Old Watercolour Society for reasons that its critics might have found hard to explain. Burne-Jones recalled of his fellow members: "[They] were furious with me for sending it, and let me see that they were.

They would be talking together when I turned up and let drop remarks about it of a hostile nature for me to overhear." The sensuous beauty of Michelangelo's male nude held a powerful attraction for Burne-Jones as we can see from the "ignudi" in the background of *The Mill* and the languorous male nude in *The Wheel of Fortune* that are closely based on Michelangelo's *Dying Slave*. As can be deduced from Burne-Jones' enthusiastic description of Paderewski's resemblance to Swinburne, he never lost his tender affection for the poet despite all the scandalous rumours surrounding him. Swinburne, Burne-Jones and Simeon Solomon were part of a close coterie of friends in the mid-1860s in which it is hard to imagine that the topic of homosexuality did not surface at least obliquely. A letter by the novelist and cartoonist George Du Maurier written in 1864 gives some idea of these gatherings: "The other night I went to a bachelor's party to meet Rossetti and Swinburne at Simeon Solomon's. Such a strange evening … As for Swinburne, he is without exception the most extraordinary man, not that I have ever met only, but that I ever met or heard of. … Everything after seems tame, but the little beast will never I think be acknowledged for he has an utterly perverted moral sense, and ranks Lucrezia Borgia with Jesus Christ; indeed say she's far greater, and very little of his poetry is fit for publication."

43. *The Blessed Damozel*, 1860. Watercolour and gouache on paper on linen, 40 x 20.3 cm. Courtesy of the Fogg Art Museum, Harvard University Art Museums.

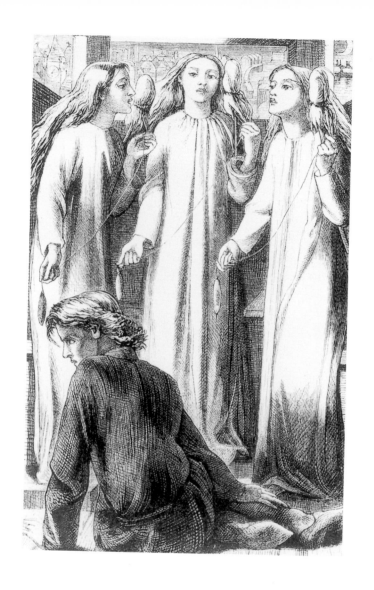

44. Dante Gabriel Rossetti, *The Maids of Elfenmere*. Illustration from the poetic suite "Night and Day Songs" in William Allingham, *The Music Master* (London, 1855). Photograph courtesy of The Newberry Library, Chicago.

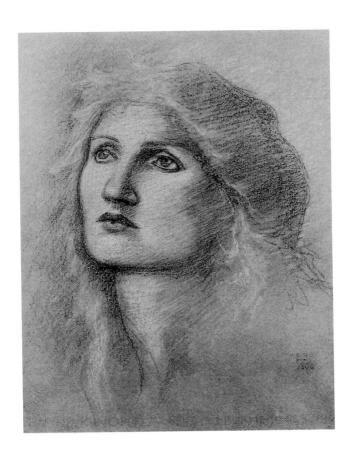

45. *Study of a Woman*, 1890. Charcoal, red chalk and white enhanced,
 31.4 x 23.5 cm. Private collection.

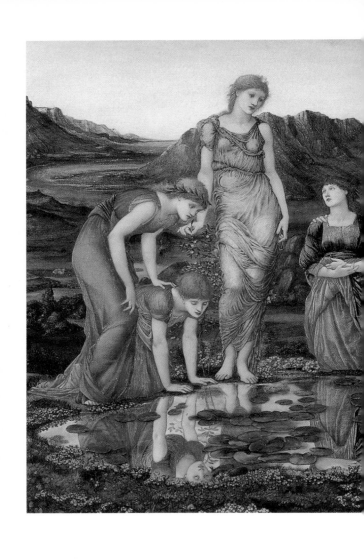

46. *The Mirror of Venus*, 1870-1876. Oil on canvas, 120 x 199.9 cm.
Calouste Gulbenkian Foundation Museum, Lisbon.

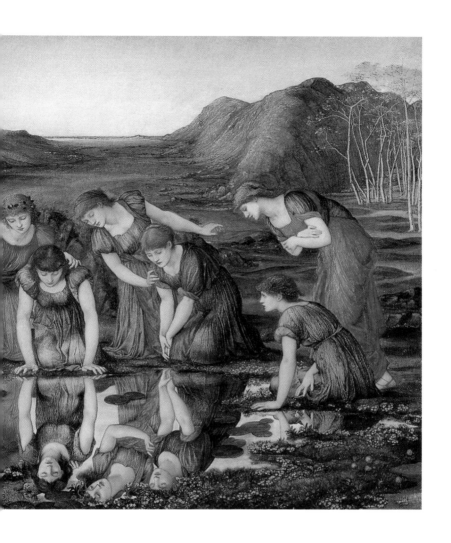

In the late 1860s Simeon Solomon was exhibiting works of a blatantly homoerotic character in a style much influenced by Burne-Jones. Burne-Jones, himself was impressed and called him "the greatest artist of us all." It is clear too, from a pair of gouaches in the Fogg Art Museum entitled *Night* and *Day* in which *Day* is - represented by exactly the kind of effeminate and swooning nude male favoured by Solomon that the flow of influence between the artists was not entirely in one direction. Swinburne has been blamed for introducing Solomon to the practices of masochism and homosexuality. He took to the latter so enthusiastically that it led to his downfall in 1873 when he was prosecuted for indecent exposure in a public lavatory. The jury's indictment of February 1873, couched in splendidly ponderous Victorian legalese, offers a curious insight into nineteenth-century prurience and prudery: "And the Jurors aforesaid do further present that the said George Roberts and Simeon Solomon on the same day and in the year aforesaid in a certain urinal frequented and resorted to by many of the liege subjects of Our Lady the Queen for a necessary purpose and in a certain and open place called Stratford Place Mews situated in the Parish of Saint Marylebone in the County of Middlesex, and near and adjacent to a certain Highway and Footpath there situated and in the sight and view of many of the liege subjects of Our Lady the Queen then and there being, and then and there repassing did resort together for the purpose of committing with each other diverse lewd and unnatural practices and did then and there commit and perpetuate with each other diverse such practices as aforesaid.

47. *An Angel Playing a Flageolet*, 1878. Watercolour, gouache and gold, 74.9 x 61.2 cm. Board of Trustees of the National Museums and Galleries on Merseyside, Liverpool.

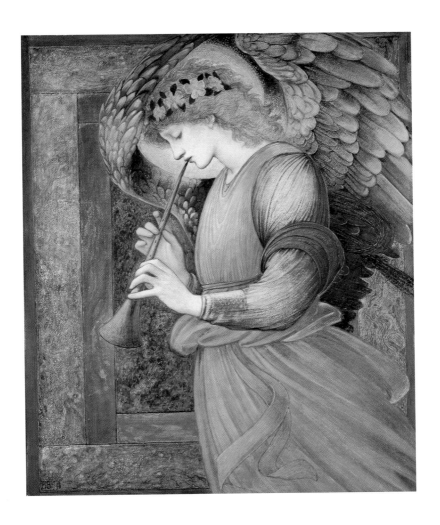

And that he the said George Roberts did and there in such open and public place as aforesaid unlawfully and wickedly expose his private members naked and uncovered for a long space of time to wit for the space of fifteen minutes. To the great damage and common nuisance of all the liege subjects of Our Lady the Queen then and there being and then and there passing and repassing, And Against the Peace of Our Lady the Queen and Crown and Dignity." It is often said that Simeon Solomon was rejected by all his artist friends after this incident, but in her biography of Burne-Jones, the redoubtable Georgie goes out of her way to write about Solomon non-judgementally and with affection, at a time when many would have thought it prudent to omit all mention of him.

No living British painter between Constable and Francis Bacon enjoyed the kind of international acclaim that Burne-Jones was accorded in the early 1890s. The great reputation was beginning to slip already in the latter half of the decade and plummeted after 1900 with the triumph of modernism. With slogans such as "Kill the moonlight," the Futurists, Cubists, Vorticists and advocates of other "isms" attempted to disperse the mists of the fin-de-siècle. Apart from Kandinsky, few were willing to acknowledge Burne-Jones' important contribution to the development of modern art, let alone that he was one of the finest draughtsmen and one of the most original and inventive artists of his time.

48. *Sidona von Bork*, 1860. Watercolour and gouache, 33 x 17 cm. Tate Gallery, London.

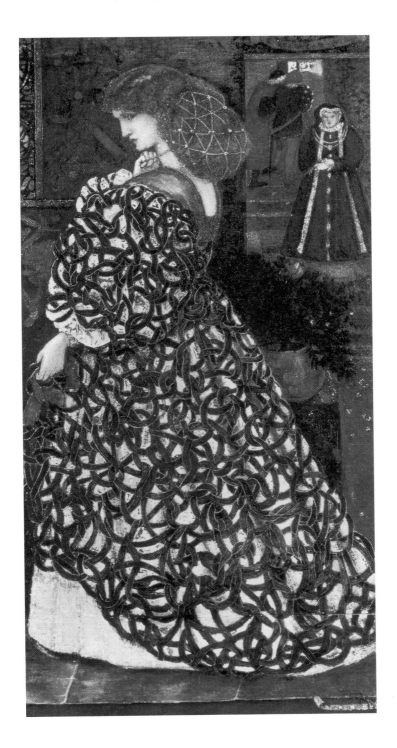

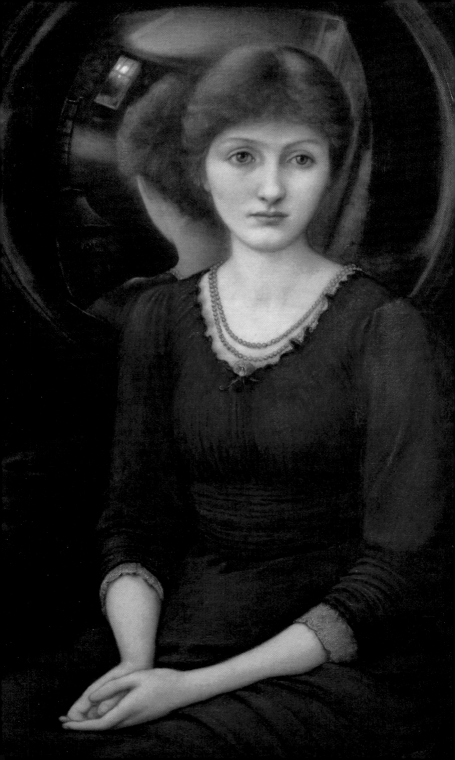

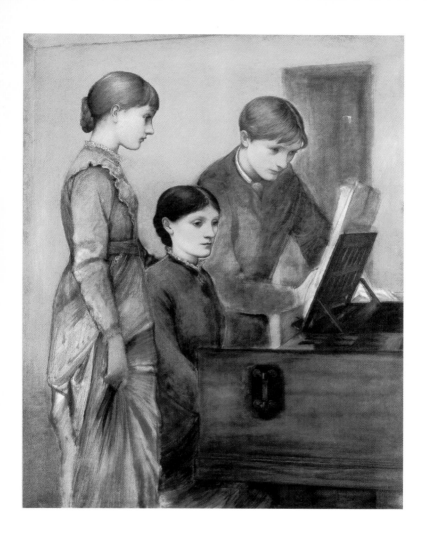

49. *Margaret Burne-Jones*, 1885-1886. Oil on canvas, 96.5 x 71.1 cm. Private collection.

50. *Georgiana and Children at the Piano*, 1879. Oil on canvas, 143.5 x 113 cm. Courtesy of Sotheby's, London.

51. *Portrait of Katie Lewis*, 1886. Oil on canvas, 61 x 127 cm.
 Courtesy of Sotheby's, London.

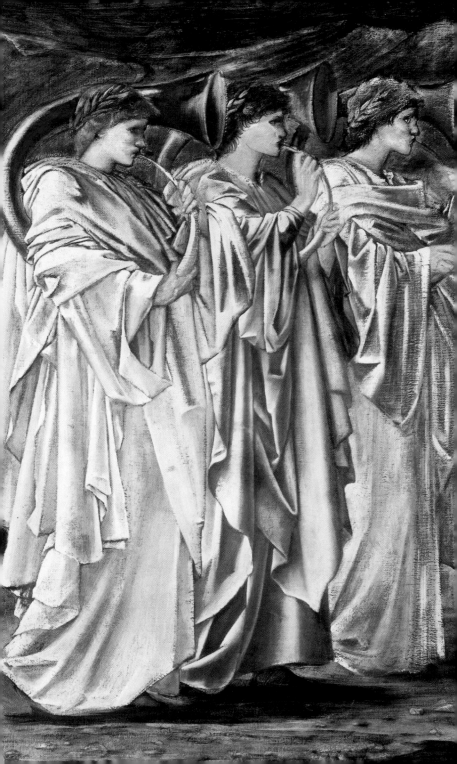

That recognition only came as another century drew to a close and prices for his works in the saleroom began to rival or even surpass in real terms the fabulous sums his work had brought in his lifetime. Burne-Jones and Georgie would no doubt have found the way that a book such as this attempts to delve into the most private aspects of their lives, extremely distasteful. Ironically, it is the way he himself exposed his hidden fears and fantasies in his works that makes them so compelling to modern eyes.

52. *The Challenge in the Wilderness*, 1895. Oil on canvas, 122 x 213.4 cm. Musées Royaux des Beaux Arts de Belgique, Brussels.

Page 86:
53. *The Days of Creation: The Third Day*, 1870–1876. Watercolour, gouache, shell gold and platinum paint on linen-covered panel, 102.2 x 35.9 cm. Courtesy of the Fogg Art Museum, Harvard University Art Museums.

Page 87:
54. *The Days of Creation: The Sixth Day*, 1870–1876. Watercolour, gouache, shell gold and platinum paint on linen-covered panel, 102.3 x 36 cm. Courtesy of the Fogg Art Museum, Harvard University Art Museums.

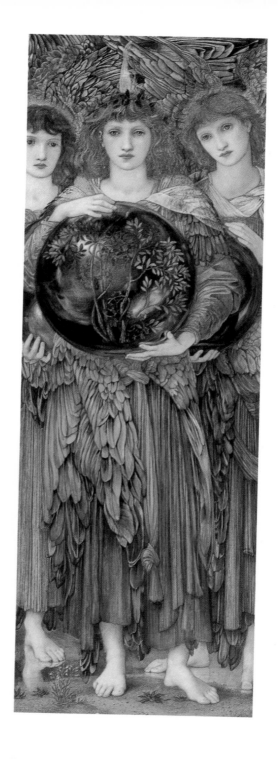

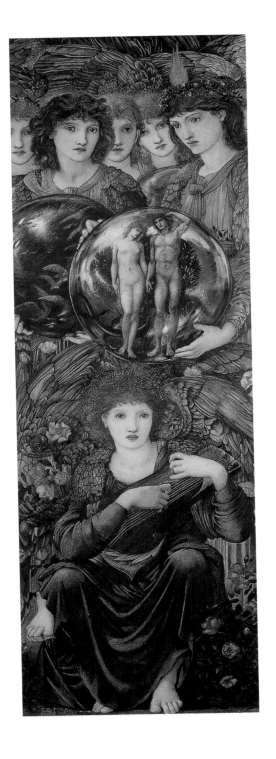

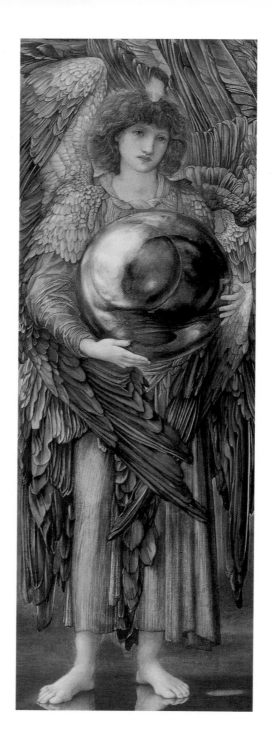

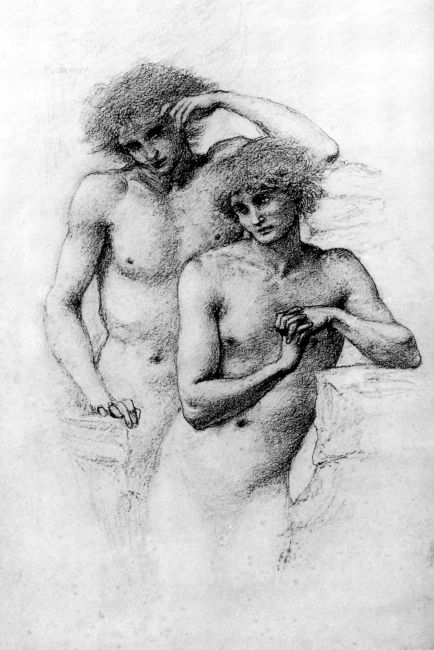

Page 88:
55. *The Days of Creation: The First Day*, 1870–1876. Watercolour, gouache, shell gold and platinum paint on linen-covered panel, 102.2 x 35.5 cm. Courtesy of the Fogg Art Museum, Harvard University Art Museums.

Page 89:
56. *Hill Fairies*, 1885. Pencil, 27.9 x 20.3 cm. Courtesy of Sotheby's, London.

Page 90:
57. Nude study for *Saint Matthew* (south transept, Jesus College Chapel, Cambridge), 1873. Pencil, 24.6 x 17.4 cm. Birmingham Museums and Art Gallery.

Page 91:
58. *Sketch-book*, 1875. Pencil and chalk, 25.4 x 18.2 cm. Birmingham Museums and Art Gallery.

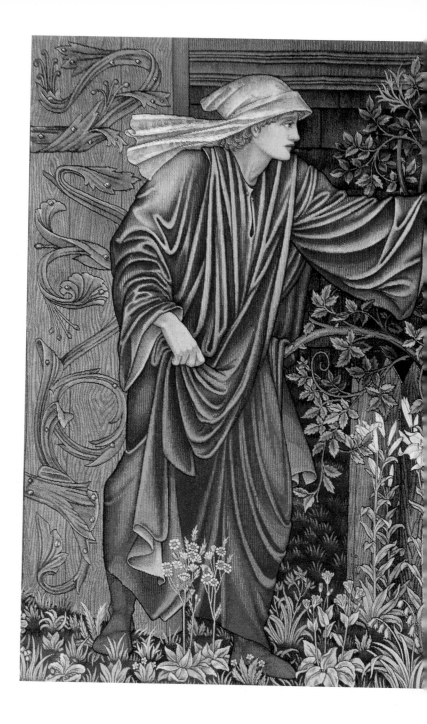

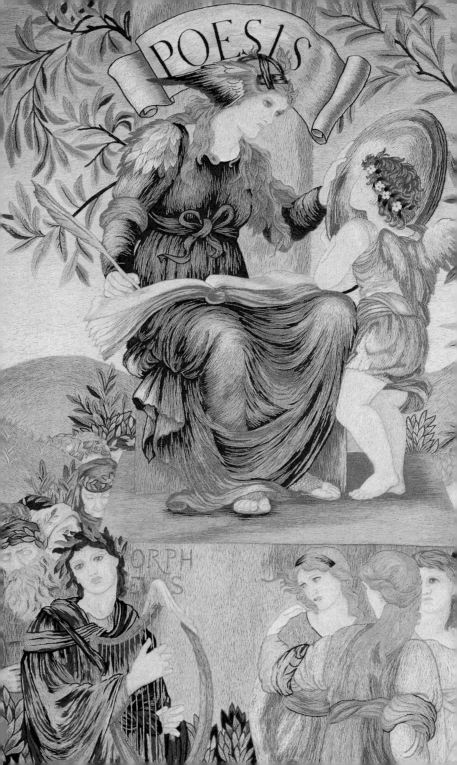

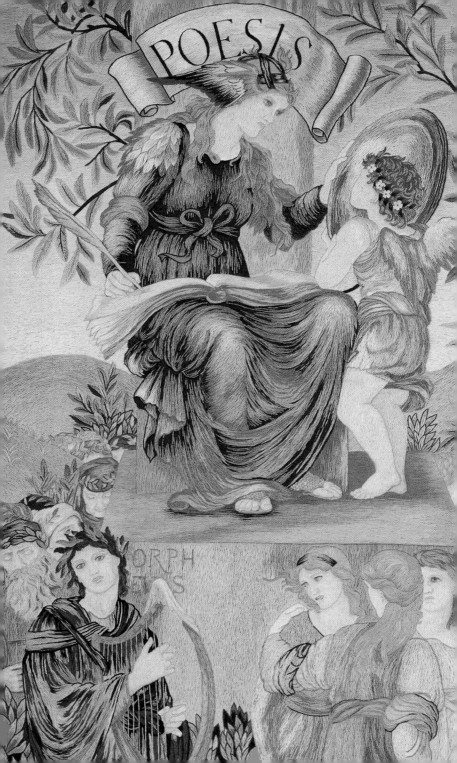

Edward Burne-Jones /
31516000865103